Refugee

6 Rooms with Marc Chagall

Travis Cebula

BLAZEVOX[BOOKS]
Buffalo, New York

publisher of weird little books

BlazeVOX [books]

blazevox.org

21 20 19 18 17 16 15 14 13 12 01 02 03 04 05 06 07 08 09 10

Refugee

6 Rooms with Marc Chagall

BlazeVOX

Acknowledgements:

The author wishes to extend his gratitude to the editors and publishers at The Colorado Review, E-Ratio, Otoliths, and Ink Node, where many of these poems first appeared. Thank you for your perennial support.

Contents

A Little Meadow with the Ruins of a Chimney 13
 après Autoportrait devant la maison 15
 après Les Amoureux en vert 16
 après Vue de la fenétre à Zaolchie, près de Vitebsk .. 17
 après Bella et Ida à la fenétre 18
 après Près de la maison 19
 après Soldat blessé .. 20
 après Le Salut ... 22
 après Le Soldat Blessé 23
 après Homme avec son chat et femme avec enfant ... 24
 après Couple de paysans, depart pour la guerre 25
 après La Vielle .. 26
 après Guerre ... 27
 après Recrue, guerre .. 28
 après Te souviens-tu comment meurt ce
 petit renard? ... 29
 après Les temps changent-ils? 30
 après Chapelet de gouttes de sang 31
 après Scène de village à Vitebsk 32
 après Au-dessus de Vitebsk 34
 après L'homme à la barbe 35
 après L'Etude .. 36
 après Le Shofar ... 37
 après Le Shofar ... 38
 après La Viellard ... 39
 après Le Juif et la chevre 40
 après La Thora sur le dos 41
 après Le Viellard et le chevreau 42

A Library for a Single Book 43
 après Le Chandelier et les roses blanches 45
 après La Synagogue de Vilna 46
 après Moïse répand les ténèbres 47
 après Abraham Pleurant Sarah 48
 après Moïse re çoit les tables de la loi 49
 après Moïse brise les tables de la loi 50
 après Moïse répand la mort chez les Égyptiens 51
 après Aaron devant le chandelier 52

après L'Éternel...53

après Dieu créa l'homme...............................54

après L'Arc-en-Ciel, signe d'alliance entre Dieu
 et la terre ..55

après Création d'Ève56

après Abraham et Isaac en route vers le lieu
 du sacrifice ...57

après Abraham prêt à immoler son fils.....58

après Noé re çoit l'ordre de construire l'arche59

après Song d'une nuit d'été........................60

après Homme-coq au-dessus de Vitebsk61

après Le Réve...62

God's Parlor at Sunset 63

après La Guerre ..65

après Esquisse pour la Guerre66

après L'Exode ..67

après La Guerre ..68

après Résistance ...69

après Résurrection..70

après Libération ...71

après Le Resurrection au bord du fleuve72

après Obsession...73

après La Crucifixion en jaune....................74

après La Crucifixion76

après La Crucifixion77

après Devant le Tableau78

A Bedroom in a Stranger's House........................ 79

après Dans mon pays81

après Le Roi David..82

après Paysage...83

après Femme au bouquet ou les fleurs sur la table ..84

après La Madone au traîneau86

après Quatre contes des mille et une nuits No. 588

après Quatre contes des mille et une nuits No. 12 ...89

après Quatre contes des mille et une nuits No. 390

après Quatre contes des mille et une nuits No. 11 ...91

après Quatre contes des mille et une nuits No. 292

après Quatre contes des mille et une nuits No. 793

The Pantry in the Mansion of Hope 95
 après La Nuit verte97
 après L'Ame de la ville98
 après Dans la nuit99
 après Autour d'elle 100
 après Le Mariage.. 101
 après Le Cheval rouge 102
 après À ma femme 103

A Circus Tent.. 105
 après La Maison rouge 107
 après Esquisse pour les toits rouges 108
 après Daphnis et Chloé 109
 après Esquisse pour le nu rouge 110
 après Les cinq bougies 111
 après Le Champ de Mars............................ 112
 après Le Paysage bleu 113
 après Esquisse pour la concorde 114
 après Monde rouge et noir........................... 115
 après Sirène et poisson 116
 après Le Monstre de Notre-Dame 117
 après Sous la palmier 118
 après L'Appel à la lune 119
 après Esquisse pour la vie........................... 120
 après La Danse .. 121

Refugee

6 Rooms with Marc Chagall

A Little Meadow with the Ruins of a Chimney

après Autoportrait devant la maison

the anonymous God
begs the universal
God for Consensus
among the cacophony of colors.
primarily
in these three notes chime more than
a Waltz; it becomes a funeral
fascinated by the first marriage
of dance to music.
a young man in a tuxedo
presents himself presentable—
Behold, this is my farm
Here are my blue pants-
Here's my Gold
House, newspapers and thatch.
my patch of dirt
and thin mushroom
growing inside it—
his God—
She invites him to
the World now
devoid of clouds.
like the petals of a Crocus
She caresses the blue
Wings of an empty chair.
one God hisses to another,
like a wide brush I am
a white soldier and I rape
all the colors like I Own Them.

après Les Amoureux en vert

in deep water
Sunlight
Warps Green-
in the deep grass
a lover,
as in depth
plunged head-
first in his lover's
chest,
his eyes
broad, his eyes
closed to her Scarlet scent.
stiffness
He also breathes the
silence
of the drowned
Fisherman and
Black
lace like drying
Algae.
she tried but She could not.
in white lace
She could not relax.

après Vue de la fenétre à Zaolchie, près de Vitebsk

without a doubt
Hidden wolves
prowl the forest,
Predators among
The stems of Aspen and pine-
sow the camouflage flowers
in a linen fan—
the family's only leaf
above the window of their home.
and it is dry
as Windhums
between the two red plums,
like a tepid cup of tea on the viaduct
Table. Trees of flax
frame their quiet
dreams.
the forest farm where
a young woman inched,
soldiers Remove a neighbor's head
and stack it up
on top of her husband's
neck to ensure his safety. later,
He smiles as she
hairtickles his ear.

après Bella et Ida à la fenétre

without glass, without glass
for windows:
She keeps her baby
and whistles to him
through a roughspun
Windwarm hood. he smells
dead sunflowers,
Bed linen, and flies
with the summer past.
and the summer is over.
and now Askew,
She prays
for your child too—
to fill out the Sun as the sun filled
the fields, please, God. buy
more blue than that. fill it
to the number of extravagance.
she prays, please—
keep this sleeping child sleeping
so they will not hear.
survive to bring a different tint
to Blue,
and another and another before the winter
will return.

après **Près de la maison**

This soldier randomly
This carefree boy slaps
red on the roof. with the girls
his mother rises,
stunned. It is more than
a piece of the Moon in the day,
his form of Bushido—
that pitching of ashes through
the window, backhand.
Light Sips in as
He raises his boot.
He started with glass. then her.
Pepper stains her dress.
embarrassed,
He flushes with heat.
in the refugees' haste to flee
He forgets to burn their favorite chestnut tree—
little blessings come
from time to time with small blessings.
but the damage
rips pity from the lenticular
perspective of polished bayonets and
the war is back and he
her husband is not and she cries, while
the drops subtle
germinate the grass on his face.

après Soldat blessé

With all of
the crowd,
Sometimes from the circus
The lion wears combed yarn
in a crown like a soldier of the wool.
beast of the beast and
Bloodmates with blood.
Leo sometimes decides to chew
through the wagon
which has its own bed.
on his table
the Circus rings wars—

A wounded corporal
wears a large jacket—
yes, that bald
one staggers along.
slapping is another
and more intimate
occasion than the Brown field
and this empty city.
streetside carnage duets the sills
with pulverized hopscotch teams.
If the world
Tinged with smoke
or just died like hedges and drunks,
who would wander into one
another for support?
empty that. invisible,
the Rainbow
and inflated tents
of the camp.
a cadaverous face matches
a corporal bandage, perfectly. other people
correspond to their bare feet. grey canvas
corresponds to

the possibility of
the water in between.
opportunity. oh, precious jewel.
Wounded soldier will you
catch a river in your hand.
like This memory.

après Le Salut

O, Clever Agent
Welcome the Green
springtime as a sign of respect.
Despite its thick layer
and - white
Roan air, it must be
flowers must be the Spring. they should be in
bloom.
color matches color
somewhere in the timelined panel
of fruit.
Since our transfer it came into dust.
true then,
It must just be frozen,
like the glaze of old man's beard, or
sparkling rose-
pure rose as
inside
when he was 21—
He plunges His hand
through his eye.
and wrist.
for some forbidden cherry
He reached.
It reinforces the original
gesture. It turns out
to be mortal. time is an intensive
moment; colors fade across
but the transfer of green claims all.

après Le Soldat Blessé

still another soldier
looks through
his last eye.
He folds his bandaged
Head to the left:
his blessed injury is
left, an overview
of an epaulette.
Red gold of disrepute.
his beard has grown
long and fallow
and tightens as it wraps the form of his rib
cage. his hair is
delicate as flower sprouts
on his chest—
some important person
tied a medal there with twine.

après Homme avec son chat et femme avec enfant

the fire rises, the family fortune burns
and they can think of nothing—
and nothing destroys them, as they run—
nothing other than
the nothing that swallows all and therefore
they birth into the world
a fleeting something like a circus—
a child, a hunchback,
the lameness of
a cat, and a miniature postman—
The characters found
Wandering the streets
of a sad joke.
later, when soldiers trample by, the War
Groups all this grey and harassed
mass together.
only the white cat is not afraid.
and how the little postman cowers and prays
to blend in with the snow.
just as traders barter
their bones for borrowed
time, so with the support of the cart a ragged pony
drags its shards through the mud.
Such refugees sharpen their hoes to worship
the Earth
on which they will rot.

après Couple de paysans, depart pour la guerre

After this war
the pools of a woman's
tears fill her left
hand to replace
her husband who went away.
his Eye. He stole its white
Linen to wear like a patch on his chest,
where once her heart was like a butterfly.
he returns.
to prove that his war is over, they make love.
Sometimes they trade
weapons in the alleys. sometimes black
the flowers grow out of their heads.

après **La Vielle**

in one case the hunchback, and
in another case, a burden.
almost a man in this position
composes an essay on gravitation—
in movement the effort grinds,
Then life.
together with himself in the embrace of work
He struggles
to be crushed, as well.
without mercy, like boxes
bought and weighed.
history is not selected, it just fits
like your own hat. On the other hand,
The hunchback has a cane,
a waterfall, and a beard to draw
his Chin down. the question remains.
Thus was he born, but to what extent does he rely
on the charity of god's dirigible chest?
What is the cost of the prayers he exhaled to fill it?

après Guerre

This grey veteran,
It's barely
readable. and
There is still the issue of
The sorting? without a throat left
to cry—
There are still sorrows
more
urgent than that to count.

après Recrue, guerre

no more use
For boots.
with fluidity the
Private salutes his lost youth
with a whisper cripple and
the trigger of a pinball machine.
"Yes, Mr. President. I was there for you, Sir!"
clack. "I crafted myself in
Morse code for this business.
now I am only noise." clack.
"and silence." he has
a few tarnished coins in his pocket.
He has flip flops to carry him
forward
into the history of war.
"There was a time when I proposed to give up
the monotony of legs
in order to prove my loyalty.
I have a few regrets. Dear MOM,
send me a note—
Tell me how proud of me
You all are."

après Te souviens-tu comment meurt ce petit renard?

at the end of the last supposedly,
The great war
the graves grew more and more
nameless. like a ball,
the head of a soldier
itself was found
to be less durable than bullets.
and at some point this one's neck
dissolved completely.
a mangy Fox frolics in a vacuum where
a human ear had been—
in the past, the useful half of a gun—
a man, in the past, his disembodied
scarf was a gift. his children are
his shoe in a puddle
behind him, his foot
still in it. but to maintain a
sense of mystery, perhaps
it begs that next time
his right hand never rises
high enough to see.

après Les temps changent-ils?

Now with both hands she leans over.
Now with two feet and various scars
On her hips, with six colors, Red
head pieces and a pine coffin—
It is in the left ditch and
mixed with broken trains.
his ticket—he whose family
cried into love notes
Nestled among tombstones.
This is a memory without name.
a memory or message
he sends forward to future
Kids. glory, glory. whose family will it be
holding the next black Note—
asking, is that my father's
puddle
Soaking into the eager ground?

après Chapelet de gouttes de sang

There are sheep.
Save the sheep
a corpse
head which disappears
in addiction, or
the widow who
disappears headfirst
into an outhouse.
let the Sheep quietly
Watch.

après Scène de village à Vitebsk

the flood is coming.
Be careful, Harlequin. an angel
falls and whips through the sky in flames. He yells.
the blood is coming.
and attention, sky—
He is really on fire. one success at last.
Harlequin has saved all the
Lights in the world for this—
the last lamp of the glory of God.
He saved this Lantern
to guide the beggars who rise
the sloping plank of the Ark.
in its shadow, the Ark mimes
the rush of ignoring—
The growing
Crimson through the darkness,
Blind of Armageddon and
Limber. Armageddon
soaks the dirt;
swans come in songs and their world on a life-
raft is a lonely
one.
a broken chicken short—
a goat token, a pink torso short—
It was God's plan to complete it. Well.
the ship floats. the ship leaks.
at sunset, the white completeness of flowers
treetops
The first island. the Pastor is blind to it.
he expected a dove to hatch
while looking for guidance,
for the menagerie
to analyze the Twilight.
without the innocence of animals,
the clown walks on water and murmurs to the
manger,

"Keep bright the lamp
closest to the Moon
as it sinks."

après Au-dessus de Vitebsk

then for a ritual year
Santa Claus anointed himself with charcoal.
Unlike the crystal night
the streets ran green,
and the grey children could see his fate.
something about a family they caroled
to St. Nicholas Day. all day and all night, all the
fifty feet, he walked
up and down a wall
in the sky above the Cathedral. He's dead
as the purpose of the Red House, they said.
dead as white crosses,
Snowbroke, but only dead once, and
off the dream of Saintly
mountains with their geometric
splendor. the end threw the load down
on them. hurt without mend.
a roar of engines rent
scarlet velvet from stolen fur. in his weariness, he
adopted this year
for the transplanting of crutches
into the consecrated soil of a veterans' home.
He took his sack of portraits home
as Christmas burned.

après L'homme à la barbe

in the new madness of Peace
The magistrate reads as a broken
index and his eyes
are trying to—
to probe his beard
for immigrants.
For example,
There are proteins from other
Races in his favorite strands and
squirrels nest behind his ears.

après L'Etude

collect five of the Apostles
under a chandelier—one holds
a soul and four candles.
they illuminate
an Engraving of the last game of Poker—
Peter folds.
Jesus turns away, scattering their cards.
Shame makes a friend
of the gesture. take these,
each of you, he says as
thumb antes index finger—
take and take and take
as the war
raises the Church
a few red chips. Obviously,
these bets rate
too small for holier tastes.

après Le Shofar

to foster a ragged boy, first
pray for milk and human
kindness, fresh from the desert.
so the Holy man begins.
Heaven is a meadow. It enfolds a
Striped cow. and the most sacred,
and the most entertaining, moreover.
It starts with horns—
their fresh scent
licks the sting from Indigo.
the udder of belief allows us to trust that
faith complicates the daylight—
what we see is what makes
peasants genuflect to the truth
and minions of the sacred clutch
scrolls to their chests and sigh
for protection. because they know
too bright is the blue iris of
the God whom they imagine.

après Le Shofar

first comes the torn
front of a goat.
Then, as a Note
lips the heavens,
the Archangel's trumpet
heralds the dead have no
Hope and no color

left to ring the church's knotty Bell—
There is no ornamentation in carnage.
There is no gold there to speak.

après La Viellard

and finally proved to be prophetic,
This old manwoman
warned her husband
there would come a day
for the baggiest of pants—
she would dress him and he
would laugh.
but she never told him
the day would bring them
in a funeral of gardenias and Gardens
of purple cabbage only—
how his legs would wilt.
She never told him
He would live on
for years without her
in the little House
he cobbled for her Robins and bluebirds.

après Le Juif et la chevre

What is the use of a goat
using the color of the Moon
on its own initiative. But moonshadow
mirrors a goat's
growth, then. the sky's face
emerges from darkness,
and so on. like the bow of heaven.
the arched bridge
and the Rabbi's ear.
the farmer did not notice his own absence.
in his hole, the farmer was too busy
intending black kites to the sky
in the form of seeds. a winter
emptiness rutted the field.
over a meal of scattered handfuls Goat asked,
If you deride
My new tent so, how then will the good Rabbi
pitch his blue Temple?
something to steal clouds
from the wind, perhaps?
Goat black skipping whispered.
Black, a proposal.
Why not create your own temple
from fabric sacks like a kite?

après La Thora sur le dos

the Scientist stories onward
While his beard grows.
to fill this small village—
to fill this void, this
village in the shade he employs
the giant and the Saintly
Box of life. and Yes. hypothesis or prophesy, it will
work. The Holy box tilts
above the village, and the village is filled
to spilling with history—
with icons and threatening.
Uncertain doom in a cupboard on the wall. Brown.
But the scientist relies on wrinkles
as a panacea against death and writers—
so written and written in stories,
they are, the people in the tiny
village. immune as authors, then. so that when
He gets tired—
and ultimately even God certainly
wearies—
When autumn stripes Heaven's back
with just Thunder he will sleep and
the little ones
will have to dance their best
without guidance or music.
How do you weave blankets of dust
furniture and the
Pious victims of stupidity? even
stones claim they will be remembered.
Thus, they will be someday
when he remembers that he wrote their names in a
history
and each with a different pen.

après Le Viellard et le chevreau

the shells whistle
in the middle of the last
night of his life.
the Farmer puts on his Emerald
Pajamas, steps
from his parlor to the outside,
and takes his favorite
Goat on his knees.
He scratches its nose
and lays it down
in the Groove of
snow. with its woolly muzzle in his hand, he keeps
his last dose of sweetness whole.
with white light a whiff of bitter
almonds and cordite.
and flakes afloat, by night just like
all the unique corpses
that dot the hem of the River.
and ashes of war hang
like floaters in the eyes of God.

A Library
for a Single Book

après Le Chandelier et les roses blanches

Lamp, fusion
Wax, white – roses
a Morning of scarves
A possible chorus.
Spray roses. Roses fall on
a Winter pool,
Light, covered with wax.
Purple sprite
and Yellow
The flame. The flame
Between feedings.
The flame is the seed of winter's
Vertical inside.
its Lines of retreat.
What God spread as heat.
a kiln for a vase.

après La Synagogue de Vilna

A study in brick, the windows filled up
After.
The hours of the synagogue gone and just a yesterday
Because white supports
The green door of the altar. Watermark,
Chandelier. Colorful.
Glass, brass, marble,
--Why your baby is crying.
Why true color
lingers
So high outside.
See? fresh snow
Blunts the snowman's rig.
The trees outside, still cold.
These walls
Stone, these uniforms. So why so, why
Wonder why the baby keeps wailing?
a Red face.
That's all.

après Moïse répand les ténèbres

Moses betroths a more
versatile place.
Stick to the sky, Angels
Start to empty.
His friends beg him to bend.
but it's not His hands
Throwing stones as indiscriminately
as straight Brands in smoking skin.
. The angels have bad aim
Moshe watches all
The victims of the law weave
Baskets from their insides.

après **Abraham Pleurant Sarah**

Besides himself.
His wife.
He covered his eyes.
When he discovered
Paleness and feeling
The cold became his God.

après Moïse re çoit les tables de la loi

A black cloud.
Smothers perfectly.
White pebbles in the past.
Offer them down
As skulls to Moses. Kiva Angels with
The words readable in their teeth.
Not worth the price, but on the other hand given
a warm Reception from Brown Earth.
an ossuary adorns a Coat of arms.
it Forms the facade
for Moshe to spray Gratitude on.
As a Leader would.

après Moïse brise les tables de la loi

Moshe imitates
Steam,
But in his own time.
Haze of rage and purple.
Moses,
He meets skulls with open arms. in them,
his lonely soul appears accountable, too.
An aggregate Board of Directors to impregnate the Earth
Green--
Until it burns.
And the slides of the mountain slump
onward From there, too bad.
The mount was an honest man.
When embarrassed.

après Moïse répand la mort chez les Égyptiens

. Father.
Downstairs, called
. The small.
Find out--
why An adult is
speaking to the sky
For advice. seems
A little apprehensive to mice.

après Aaron devant le chandelier

Rod of Aaron
Thy face a Nebula
For jewelry.
wear it as Advice.
as Leviticus.
Patriarch Pools candles into
a Ship of light—
and a hope for the long coffin to fit.

après L'Éternel

Eight Angels were
Atoms of glass blocks,
Admonished to talk if and only if it is a great thing and
needed.
There is a hand smaller than haloes--
the Wing of an Angel and shrunken,
An Angel speaks through the whispers of the Moon.
Blindness looses a stooping Angel.
An Angel to give up under the guise of home--
An Angel becomes a clown for soldiers--
An Angel carries swords-
An Angel is an Angel
weaving its holy stole from
Something that we cannot see-

après Dieu créa l'homme

If the images are to be
The reliable and rash words
and a billion testaments' worth--
despite what we believe about beauty
God spoke, and God created man from
Two old pillows and
A fried egg.

**après L'Arc-en-Ciel, signe d'alliance entre Dieu
et la terre**

God can thrust a rainbow
Just to punish tired parents.
-Which, on the left, stumble downstairs, and why not.
Don't forget gravity.
Do not forget the language of God, bending the light
gently
Into the glow of a hoop.
red, green, violet.
Dear friends, these are
colors he's crying.
Like any other attentive lover
Of the Earth.

après Création d'Ève

Over time, the ideas of God
sink Deeper when chained
to images. into which the moon plunges.
And judging by the picture, this handicraft of
an Evening of dominant
Clouds drowns while Adam falls—
like a deluge of rain
lashes the empty
streets and leaves
sick wards full of
Patients with another breathless cause for concern.

après Abraham et Isaac en route vers le lieu du sacrifice

the artifex decrees a trinity of glistening--
Large knife and Abraham and a candle. Going
On about his business.
The Maccabi of devious means.
Green night taunts a rebel with a blue sky.
does he indulge in rage?
Tourist services around Isaac are grouped.
see The small altar's hardness--
the baby is almost alone on a rock.
And Abraham, behind his ear
God whispers--
He's just like an obedient son,
so carve your name through him.

après Abraham prêt à immoler son fils

A cracked Angel perfects
the facets of haloes—
meticulously—
an aurora it cradles as
a sermon with both hands.
ragfingers curtain mortal eyes.
tarnish rubs from
silver. Abraham, you cannot see it, but
God is a village in the sky.
and a bloodwashed home.
For your son?
a bath sanguine as lost roses, and you,
You are not grateful.

après **Noé re çoit l'ordre de construire l'arche**

whereas the mortal coil
represents an unbearable
Nuisance to some,
When the Dark Angel
Descended
It spread its wings
convincingly.
with what lies in slander—
To claim that she had a gun,
or needed one, for coercion's sake
A flood is coming,
She announced.
Noah, you create a
Box or learn to tread water.
Noah said, but my head.
My head is a huge
figure, Drawn from the profile of God.
Unimaginable. How can I swim?
She said.
Then you will drown in love. If you want.
No, not from me.
you have to cut your trees with axes
and All your children with knives
like disappointment. I saw them last when
they were 7—
A little time;
now there was a jug brimming with wives and happiness.
but now You have your tall sons and your torches.
You can practice pious carpentry
while erecting their biers. take note
of their skeletons in the coals, how they mimic
the fine ribs of a ship.

après Song d'une nuit d'été

the first miracle
gladdened a wedding—
Mother married herself
to the joyful goat. scarlet seemed like
loaves or Joy without
Stop.
Harlequin Green
Music, optimistic,
from violins the Angel looked down.
The Angel with even hand.
Down on the Azure Lake.
Down on the rash blossom of
the pregnant Tree. the blush of the bride.
a wiggle of permanence trickles like prayer-
Fans of blue spread,
Nausea through
The sky of the sky.

après Homme-coq au-dessus de Vitebsk

Triple chicken foot.
And a fire in the sky—
a constellation of
Color—
Makes all vengeful, bloods
the silent steeple of hope. Winter Moon—
One warm up from November light.
Fuzzy grey, then.
a Black and white then.
The storm has blocked the city with rows of tombstones.
it Disappeared with Marguerite
among The bones in the ground.
the mounds of yesterdays.
And above all, the Moon
Shines as bright as if.

après Le Réve

and how is the dream different
from any other funeral?
Godiva's shade straddles
His cortege
In a gown sparse as poppies.
like a fable told with clouds of grief,
The increase in water courses—
tears Of lust and sorrow
channel The steps and more deeply than
an elegy for sleep. When God yawned, Her purple mouth
filled with the Cosmos and food.
The fragile eggs of
Rainwater collected where
Trees grew down from the Earth—
Where trees had fallen.
In the dark and moisture.
All the people in black armbands
lined up To cry for
The beauty of nature exemplified in a grave.

God's Parlor at Sunset

après **La Guerre**

Instructions for
the Operation of War -.
first nail a goat

Head to the sky,
the stars there, the stars -.
share his lids. let the gravity spill

his eyes out like bombs. cry,
Why don't we celebrate the children?
skip their scars by dodging

machinery and
the resulting flame.
just try to keep your baby safe

while the vineyards
of your village are curling into smoke -.
gold rings and the oak staves of

your childhood love.
Run away. Look for your
Brother, who hid in the corn.

Search for your grandmother
on top of the wagon's planks
but under the pile of 's legs.

après Esquisse pour la Guerre

If only anyway -.
If otherwise unavoidable -.
If only because

a huge goat would eat
the world, or naked women would
reluctantly dance in fire -.

That would be enough
to justify the grey
Chaos and carbon.

to make the souls of the poor crack
from their barrels?
Imagine a before. can you imagine

a story without?
a woman holding a hand
asks her husband why -.

Why have you not noticed that,
My darling? What are you doing while
your Head drips its memories

on the ground? am I to be left?
Meanwhile, only a wealthy
Family has found refuge.

on the giant neck of the goat they ride
and sleep through
the stench and the screams

sound so beautiful from afar -.
a more tragic excuse
for a view misjudged.

après L'Exode

Yellow has a black Jesus
in his Eye, but he holds fast
to the blue Madonna and

the Garnet village in flame -.
is painting a frivolous response to tragedy?
Oh yeah, the war. Oh yeah, people are leaving.

the bride in white wanders.
Her unborn child rides a chicken
home to the goat in the sky -.

the fish in the sky -.
to the spoon in the sky -.
the sky is an ocean

and our ships sail away.
the sky is in splinters of lost creatures
and cutlery.

this storm is an ocean.
and yellow.
For dear life, Jesus is hanging.

après La Guerre

Horse breeding -.
Mercenaries. Poultry.
Loads of blood. and more.

the Red Lady accuses
the soldiers of further; carnage
blunders their toxic

yellow sky -.
if only it were the end of an age. You may not
convince me, She says and she holds

an infant tight to her breast.
She rides a ladder higher
than broken horses -.

above the charnel house there is a Way we used to
be kind to Chickens and now
away a beggar creeps back

in with His beaten
cream cap and his
Sackful of meat.

après Résistance

come the victims to harvest
and to drown in the Red flow. night doused in oil.
Red slopes the resistance

with a veil – white like
a horse imitates
a torch

touched to a thatched cottage
where resistance sleeps. the horse
carries flames through alleys

to signify the sacrifice of virgins -.
an odd choir begins to fill with
only women's voices.

Versions of the light in violins
and soldiers. see -.
murder is a fable brimming with toys.

the woodsman wields an axe at
an imaginary Wolf. but it is only his grandmother
wearing a blue coat. see -.

the war ends with a moral or never.
the Ravens in economical
Butchery both sharpen their beaks and

Measure up heads to feed the Parade -.
there is still a smidgen left
for a celebration to follow the armies home.

après Résurrection

in dark rooms the judges
weigh testimony
between a lamp and a flashlight. It is said. It is said.

a crimson truth is thus illuminated.
a red truth, lit.
Measure as if you were Jesus Christ, and

ponder -.
do I like the innocence of a flame in darkness?
they heft their gavels gravely.

they use a goat for dictation -.
its writing decrees one survivor
be wrapped in a sulfur skirt and

free! cries the judge. the jury
looks forward, rising like a mackerel
from a Bank -.

so this is the fate of soldiers, to be
a symbol of silver redemption
or just a simple fish. the defendant meets

their sighs calmly, and unwinding coils of rope
Anoint him as if a bailiff could
acquit the Savior's joints with oil.

après Libération

showtime.
the liberated Savior
Mounts rickety stairs

to a direct hit -.
the dead center of the room.
He throws his violin, He claims the red circle

as his very own -.
all eyes train on him.
the sanctuary is inhaled

from the bellows of a holy tent -.
because this is also a church,
the bride and the groom take

their usual positions
under a sacrificial awning.
This is the tradition in places

where waiting for love is still observed.
everything seems ready.
so the choir begins with music,

in the sacred chords they were taught about home.
and What is a wedding but a yellow House
cradled in an orchid.

après Le Resurrection au bord du fleuve

She was a beautiful girl - the gentlest sentence
proved premature. as a child she was orphaned
forms an angry sentence.

The world turned mother.
Desperate purple
for her child's

pale face. She hung the Savior in effigy
After the new moon.
over a blood-red river -.

above the ghost of a girl -.
she Who smelled the flowers?
asleep now

forever in a pit of the Earth -.
this Image split a painter with its head.
half horse and half man—

a master of scarlet and Indigo—
He secrets such scenes of death
for subsequent deconstruction.

Women's stories.
the lost children by candlelight.
and in this glimmer of hope his patrons thought it

easier
to pull Purple from red to recognize human yarn.
When he draws the face of a girl

he draws a shroud
Who receives hyacinths,
but not kindness, from the left hand of God.

après Obsession

Visit each
Detail to worry color. Wood. Blood.
Mud. and entrails.

men drive cartloads of
Babies out of the burning house.
Their mules to ride

Exhaustion. You know the chickens died,
and yet you hold out hope
like a bouquet. Nothing remains of the world

but color—
stained feathers and the
Color green such as an April Savior wears—

MOSS has fallen
on the Earth in a wreck of candles -.
it smears the wheat fields with fire.

there is no escape from this rising—
Smoke combines dark lines of narrative.
noble grey back with red,

trauma a farmer to his legacy, his blindness, his
lonely -. Grossmutter—
Who tends the night?

après La Crucifixion en jaune

where are all the finches in this world?
the Green Angel blares
his trumpet through a fern beard -.

ancient as forests,
It Claxons the time come for burning
Ships to sink

into The ochre-coloured sea. all ships have to sink
in good time.
It's time to build
a ladder for His only Child to climb -.

Cut the tree that God
claims for Himself. It is the time.
It's time for indigo

Faces and blue goats,
to rejoice, the beggar has found
a stick to lean on.

and despite the fire and ruin,.
under the Rainbow Pietà
and after the storm

a lush bather
Catches fish by hand. so gentle.
and in school all are taught cowards

are yellow. So, even the sunflowers.
A fish cannot hold what is.
What is a Carpenter

of people to do but drown? perhaps
peel a green scroll from the skin of the Angel—
the painter makes a wax Angel -.

so tall and so graceful, there tapers
in a candle a chance
to torch what remains of the trees.

après La Crucifixion

Maria mourns the death of pretty pictures
as the death of sunshine
in a poppy-colored

poet shirt. She wipes her eyes.
a chicken looks up from the woodblock.
Sometimes there is no

Explanation of grief but image.
one black and upside-down—
the other a Rat that lights a candle.

Purple flame on ground falls—
and waits until the rat licks
The worst of the bleeding to a stop.

après La Crucifixion

the cock
on the right arm of God
explains in the morning

that the sun
and Carpenter
are also dead.

après Devant le Tableau

an absent-minded teacher
Charts the primary
Players on a Blackboard—

web, Goat, painter,
Angel, mother Moon,
Chicken, soldier,

Body, clinic,
Candle,
and burning houses.

yellow, red, -.
Blue and green.
the teacher

weaves chalk webs between them all.
This is the story
We have received.

Parents celebrate—
mass in the background
and mill, less than

the expected grist.
the White hand presses
the open wound apart.

A Bedroom in a Stranger's House

après Dans mon pays

in the lovers' youth
the sky was once

an azure horse
who cantered between clouds.

a pink goat drank
from the horse's bucket,

chicken and man were still one—
face to face, smile to smile—

in a word, harmony.
in the lovers' silver

youth, their barn was a refuge for kisses
and the fish-moon leaned closer

than home, while the goat
drank his fill of milk from the sky.

après Le Roi David

in twines
of notes and words,

the king of leafbeards
plays a song to the longest

woman in the world—
a beautiful tune to reclining,

but his wife grew opaque
with envy. she spoke no harsh nothings.

she left that to the poet—
although only a witness

to her jealousy, the poet turned young,
green as bindweed. he dropped his book, he

rummaged everywhere
for another word for blue, he

clutched his heart, he slumped
inward. and inward the sun

shrank before wisteria blossoms—
which is the light of love from a chicken

for a beaming goat, a light to watch over each other
and also over all colors without preference.

the wife and king lingered ever after,
as pictures in the minds of children do.

après Paysage

to the infinite
mortification

of the painter
who lost control

of the scene,
his saffron angel

delivers only the left
half of a periwinkle woman

into the artist's chosen orchard.
in contrast, the goat appears wholly

amused by the bifurcation. his carmine
bride and cat do not.

après Femme au bouquet ou les fleurs sur la
table

a damsel reads
poems by moonlight.

it's just what
damsels do.

by moonlight, blue
poems grow

flowers while in pigment
a chicken gauges their value.

by azure chicken-light
poems bloom

to be red—
she reads

bits of fruit and chicken
into poems with the

hunger of moonlight.
the hunger of

moonlight swallows
poems into its house—

its blue rooms—
and cobalt,

the moonlight
into which both

damsels and
asters bloom.

après La Madone au traîneau

in another life the chicken
lived in an azure lake

with two flat faces and a ladder
which leaned all the way

up to the goat's head.
back then the chicken

knew the goat. the chicken knew
God. in another time Mary

was a mermaid and
her baby an anemone—

a little halo in the sea—
all fingers and drifting.

and on land all the horses had
scarlet heads, and all

the cottages shone maroon.
their bedrooms marooned with two

faces watching
over, and a poet watching over,

with the farm and the moon and
the goat watching over—

as with love, Mary proved

the constant mother—

in another life the chicken had nothing
to fear but stories.

après Quatre contes des mille et une nuits No. 5

far beneath the swimmers—

...

...

...

...

...

...

...

...

...

...

...

...

the mermaid drowns.

après Quatre contes des mille et une nuits No. 12

over the moon, and over indigo—
...
...
...
...
...
...
...
...
...
...
...
...
...
...
...
...
...
into his lover the gallant horseman leaps.

après Quatre contes des mille et une nuits No. 3

only the sudden appearance
of a macaw could

 ...
 ...
 ...
 ...
 ...
 ...
 ...
 ...

distract the boy

 ...
 ...
 ...
 ...
 ...
 ...
 ...
 ...
 ...
 ...
 ...
 ...
 ...

from his desire's derriere.

après Quatre contes des mille et une nuits No.
11

the moon absolved
the lavender horse for being

...

...

strange, and also the varied
lovers wherever they lay.

après Quatre contes des mille et une nuits No. 2

infamous in verse—

...

...

the scarlet ceremony always

 ...

 ...

 ...

 ...

 ...

 ...

 ...

 ...

 ...

 ...

 ...

 ...

features a belly dance
by the queen of serfs.

après Quatre contes des mille et une nuits No. 7

dreary angels, lovers—
children, all—

...

...

all and mermaids merge
in bellies, to become

...

...

the infinite love flapping in
a four-winged horse.

The Pantry in the Mansion of Hope

après La Nuit verte

by definition, a minstrel is god in a stolen skin and
he pieces together quiet music.
These are the waltzes in which
young paintings grow. he sings how
the goat of beryl in the sky
celebrates a new life – for the painter
has married the Moon
While the village slept.

après L'Ame de la ville

these are poor words for images
of the divine will: the light, the Sun, the moon.
the painter cannot decide
between blasphemies.
a portrait of God or a bucket
spilling paid ghosts of heaven—
the eighth day, the bucket pours like creation, as
an act far from completion.
a lurch
under the brush of the blue party goat.
the bulls, too, doodle in the sky of the egg and therefore
the mother of all the chickens—
These all come
to be distractions.

***après* Dans la nuit**

the urge to make love
by goatlight
dims the brightness to a reflection
of the moon.
novelty ignites
in the wick
of lips. Once, at least, this could have been
a hooded lantern in a constellation
of conifers.

après Autour d'elle

born of a painter,
a fugue of canvas
beautifies wakes.
a Lady dreams of
a picturesque marriage
in Paris – roses, sculpture garden–
She's waiting for herself. She's waiting for the sky to break
into oceans.
daytime quivers there,
until a siren goes down
wearing a snowglobe
the size of a city.
the dreamer steps in. she admires Fractals
more than snowflakes, she
waits for an intelligent pigeon
to learn how to light candles.
in darkness She shudders her Chinese fan
like a lion fish.
the morning, it returns as an hourglass–
Head of the painter on its heels,
It leaves the pigment to dribble
softly in his ear.

après Le Mariage

Moon or cello, married or married.
as the rays pale a butter lamp
they are apparently ignorant—
in their indigo
they don't know who spurned them.
the drum is lonely as a sunrise.
the drummer plots revenge. this is
the composition making fun of the background,
but someone there
has dumped a tambourine. Imagine the hate.
the wicked musician bribed his servant at risk—
So subtly, very subtly.
to expose his white chest—
flexible as a gnarled Cliff.
silver bangles shimmer like
neighborhoods between his feet
and neglect all lovers' pleas for mercy.

après Le Cheval rouge

nightly the night bursts spontaneous
but planned as only a perpetually -.
pirouetting dancer could. as a show tonight.
the circus foreshadows a circus—
a minstrel, a chicken,
a thief of flowers and a wedding of unmet lovers in a stack
of acrobats. for the finale, a peasant woman sings
"Frère Jacques" accompanied by a calliope.
inhale the steam—
round and round, a Stallion Scarlet with Scarlet
hands for hooves
and his personal pole-vaulter Gallop
circles around ceremony—
circles extend from the tent over the horizon as songs.

après À ma femme

of course the odalisque
reclines, of course she's expecting
the OWL and the black
time for her Red Angel return—
and back and every night to
to a populated world.
she attempts.
it is only a painting,
she says, vagueness
requires a more complete world.
each attempt full of features and
brushes – the rotating band
of artists, I love you's, you're beautiful's,
beautiful like the Angel bearing
Blue goat gifts—
These daisies, these chickens,
these reds of Rhode Island comprise
the ornament of this nest.
but the solitude of a particular painter
is different, this offering oil separates
from the rest. for portraits She gives herself
a grey fish with an umbrella,
a fan and two heavenly breasts.

A Circus Tent

après La Maison rouge

For a second sets the rare
call of a nightingale.
It is possible to build a good circus
Of love and colors -.
alone,
The audience is impatient to be optimistic.
The groom has to climb
an Apple tree, given that
Marriages grow from green germination.
To intensify the performance
tarry the Running light – turquoise
. Hi, from the rooftop of the city
trickles the brideless spotlight.
RIP, the bridal bouquet.
Poof, goodbye, goodbye – PLoP swing by tophat Springs
the magic. Waiting in the shadows is
loneliness. the mood changes
with the agility of a kaleidoscope.
The opening of unlikely curtains
Opens, his car, a woman arrives, then.
Walks with her lover to the tree.

après Esquisse pour les toits rouges

The Moon is.
The Moon is a puddle of water.
Stars. This Spring sky
loved the river alone.
Carrier of lovers,
Spirit and orchids
Only, so that a memory
could fill a little car.

après Daphnis et Chloé

Once again.
The first love story is told for
The purpose of Grace—
The second person,

you,
Shape flowers
with the Simplicity of smiles.

après Esquisse pour le nu rouge

Red Lady
Bird. She
Like no other.
She imagines that pigment is created equal and
Brings her painter black.
in Chrysanthemum
She grew up, she the one inseminated
With the ashes of cities.
The roots of his grinding
on her. He is in his peak
Heavier than a ghost
With a belly full of flesh.

après Les cinq bougies

It is not entirely clear whether the handle was
united with
the Trapeze artist until she fell.
Do not understand the difference.
It was funeral flowers—
their Measurement in the mouth.
Punch was five years old.
Crowns kissed his mother on the head,
in the rain. the rain,
It has flowered white as the moon.
so orphans Continue happily on Earth.

après Le Champ de Mars

the Nightingale,
to Sarah two tulips
He showed.
On the Trocadero. Purple and gold.
But also he offered the Moon and
its Tour of the world. just consider a person
a Green light flashing off
A scale—
The flashing lights as the evening star.
of the Song in the night later
He remembered little more
than a metal tower.

après Le Paysage bleu

Nightingale
Moon the Moon
Fish-raves
In addition to
the Fans of his headdress.
Now alone. She kisses
His Chin with both hands,
Their anatomy blue and blue
Lips, and gently he disCovered that
the Moon had slipped in.
Behind the screen a demolition in reverse
protects the District of indigo.
or just call it the night.
oh darling. Dress like a fish.
Be creative in printing.
make a Home like a Rossignol
on the eaves of a Star.
Right away. Or only slightly.
Love of wood spills from the trees.

après Esquisse pour la concorde

Duchess throws her Obelisk of
grief redacted
For the Central tent pole.
but who is the Duchess?
is she but
a bystander, and loveless for it?
tickets to the circus are cheap.
If only this solitary
Apology.
Facing no resistance.
Not in their resistance to the stone,
refugees cannot spit on conquistadors.
Not ungodly sideshow people.
one Deity uses his stubbornness
As a pretext for rivers.
and what might I be allowed to do
for entertainment, to postulate
The intricacies of how to justify?
and babies—
Please excuse this.
Gardens,
She said – and this is another
God—
used Vases for flowers
And His apology. but to prove the Preludes
To be true as a tree,
first God's Reflection must
apologize to wood.

après Monde rouge et noir

Somewhere between the gaps
time spawned
From dawn to midnight,
Roustabouts handled most of the construction.
A Circus. And, finally, .
The show fills the world.
finally arrived.
Switch of linen, which after all is only
the Dress of a bride—a goat in
All the purity of the innocent.
never forget
The confusion of a wedding night. Mary—
She is a mermaid
like the Secretary of the Minister
of the priest whose
Ministerial seat covers the sky with velvet.
Close to the Sun a happy bride flares red and blue—
dear Fuchsia Cope-singer
of Loud music
Whose hands are always full of rope—
In that framework,
Love can be the world.
a Summer meadow tips to wind
And the peaceful tent ripples
in Lavender rows. content
with the scent of Lavender,
a chicken roosts with family for the night.

après Sirène et poisson

. Baby
For the bees.
Bat Yam, fishmoon
. Treatment and tarnish
Drown the Indigo
Palm trees.

après Le Monstre de Notre-Dame

. Blister. It's like a circus
In three dimensions and not two
Sky and sea and.
an Artist.
Beyond the horizon the spectacle eats—
Circus Maximus. whether
Chicken or goat or the
Sailboats of a dream—
Rain pours outside. on a congregation
As in a dream of Onyx
Weddings. cast In normal mode.
even if they have fled the elsewhere.
Wall and floor rumble
flesh for goat, the chest for Pigment Green.
In this field they memorize all the weddings they've seen.
. the Bride raises a very sexy Uschi fist, white
like the Butterflies of schooners.
like a Mermaid fish moon.
a Painting on canvas holds its breath. . To listen,
Folds of fabric white whisper.
Chicken is poised on the end of a kiss.

après Sous la palmier

After the completion of
Palm trees
Read the Moon
. Bay. Circus the honeymoon as
a Debris of tents in the hibiscus.

après L'Appel à la lune

Ventured now the Cardinal Tower
up and up into
Your own paradise—
how young Your skin, as promised as a parachute
Sewn to your skeleton with intention.
how the Kiss of the moon silhouettes a tent.
now Kiss and love,
Lovers of the city.
remember when you were there.
how the artists all said,
Here's the kiss and the Kiss is Love.
Hunt your ghosts or your personal green curtains or
orientation
in the Department of Incredulity.
Remember their faces when the bombs whistled.
Reflections in the summer sky.

après Esquisse pour la vie

I am a poet, so My apologies
for life is a circus.
There is no excuse for this drivel.
We live in
a Wheel, and while I watch
I Can't say this Clown and that dancer
celebrate it, even in all the colors of weddings—
afterbirth and all—
the Beautiful brightness in the chromatic uprising of fish.
Here no excuse can take the place of the moon.
so go ahead and
Believe in Mermaids or Angels.
Or that the end is tempered.
that There is a war and an edge to it.
The result belongs regardless.
Chicken and Goat can fall in love with you, you know.
what other reason to love
but to smother loneliness.
a refugee scrawls
tender rainbows to his billowing
tent.

après La Danse

shades of friends all attend.
seeking some happy refuge,
for The last time in his life he's an artist.
Blush of goat
Puts clothes on the Harlequin.
Oh Harlequin, Black Diamond starts you
like a Cobalt violin. She pulls the sheet down.
a Wedding Dance channels all the minuets
She played for the Queen.
Girl, she plays Green so green
the Sea man offered her Freesia-.
all fans spin flowers in wind. Interlaced
Like God in periwinkle beds.
Layers of paint, to caress the fabric under—
And soft. The Savior has been
Beloved back through this story.
Hung out and lonely. If only
he could enjoy the life of a Chicken now
for free, if only
as a reflex.
stiff brushes
Wars and response time.
And wanderers of memory—
paralyzed by trying so hard.
The love life of the smiling tempo flatters
a cow waltzing,. married life.
someone
observed the High fish point with due ceremony—
the apex of silver
Overwhelmed by Luna.
correspondence by image—
The artist to toolmaker
Breathes, drawing in the sun.
Violet and her all, magic and light.
She was the Queen, regal and

she Walked on the hands of the artist.
Marc and Luna and Goat,
the names of lovers fade
without a stain in the world.

Author's Note

As an author who usually tries very hard to be a good parent to my own creative endeavors, as a rule I don't like to frame or contextualize my poems. Rather, I like them to stand on their own merits without suffering my continued fiddling with them even after they've been sent into the world. However, I in this case I acknowledge that a reader who is not already familiar with the works of Marc Chagall might have a few questions about where these poems, images, and the somewhat odd characters within them might have come from. It would also be a grave disservice not to acknowledge the painter and paintings who inspired them.

And so...

These poems were originally written in a span of six hours on June 28, 2013 in an exhibition titled, Chagall: Entre Guerre et Paix, at the Musée du Luxembourg in Paris, France. Each poem corresponds to a work of art in the exhibition, with the titles following the traditional ekphrastic form of "after ..." Due to licensing fees and logistical issues, it has not proved feasible to reproduce all the art here in a paired format, but a curious or intrepid soul could find the images on the internet, if he or she so desired.

The exhibition was curated chronologically or, in a sense, biographically—and so the poems that grew from it also follow a similar line, tracing the embedded narrative of an artist's life throughout. In an effort to let go of some authorial control, I put these poems through multiple forced translations that mirrored the pattern of Chagall's own forced movements throughout his life (from English to Russian to French to Hebrew and back to English, for example). Some scars traces of this forced linguistic

emigration remain as atypical emphasis, capitalization, syntax, and punctuation. I have chosen to keep these intact as they first appeared, as an acknowledgement that I will never understand all the nuances of the refugee experience, but they are nonetheless quite real.

Travis Cebula resides in Colorado with his wife and trusty dogs, where he splits time between writing, photography, teaching, and restoring houses. *Refugee* is his seventh collection of poetry, and fifth published by the inimitable BlazeVOX [Books]. In June you can find him working on a new book and teaching with the Left Bank Writers Retreat in Paris, France. The rest of the year you can find him in a cloud of sawdust and weak metaphors.

Made in the
USA
Middletown, DE